ABANDONED
CHICAGO

ABANDONED CHICAGO

DECAY IN THE WINDY CITY

ALISON DOSHEN

AMERICA
THROUGH TIME®
ADDING COLOR TO AMERICAN HISTORY

America Through Time is an imprint of Fonthill Media LLC
www.through-time.com
office@through-time.com

Published by Arcadia Publishing by arrangement with Fonthill Media LLC
For all general information, please contact Arcadia Publishing:
Telephone: 843-853-2070
Fax: 843-853-0044
E-mail: sales@arcadiapublishing.com
For customer service and orders:
Toll-Free 1-888-313-2665

www.arcadiapublishing.com

First published 2021

Copyright © Alison Doshen 2021

ISBN 978-1-63499-365-4

Typeset in Trade Gothic 10pt on 15pt
Printed and bound in England

CONTENTS

INTRODUCTION

I was sixteen, walking through a wooded area that surrounded the eerie waterpark slides. What once was a place for teenagers to cool down at during the summer months is now a playground of ruins and decay. Bright baby blue slides covered with colorful graffiti that was now hidden behind the fallen leaves from seasons passed. Walking up and down the old waterslides, it felt like I was in another world. If you climbed all the way to the top of the water slides, you could see the cars driving up and down the highways below. It was a memory and feeling that I will remember forever. It was a feeling I knew I wanted to experience again. Little did I know that this would be something that I would become so passionate for.

Later in years, I am married to my husband, and we find a common passion for photography. What began as visiting and photographing old cemeteries developed into exploring deserted locations and learning about their history. We visited our first abandoned location together as a couple, an old state hospital, and I had that feeling again—that nervous, excited, scared rush I had felt at sixteen. Walking together through the mosquito-infested woods, we finally approached the worn-down buildings that were still standing. There was an old barn with an orange rusted metal roof, a small brick building with a bright turquoise-tiled bathroom, and many other dilapidated buildings that were now piles of rubble. There was even the old chimney stack from the crematorium that was still on the property. Spray painted on the wall in front of it read "RUN" in big red lettering. This gave the exploration a spooky feeling. We both knew this was something we wanted to continue doing together, to document what use to be and to show others a look inside.

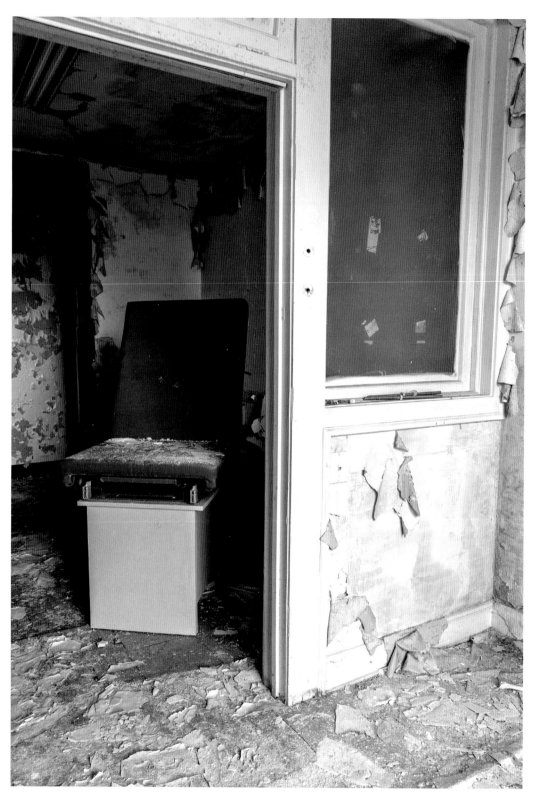

Medical chair.

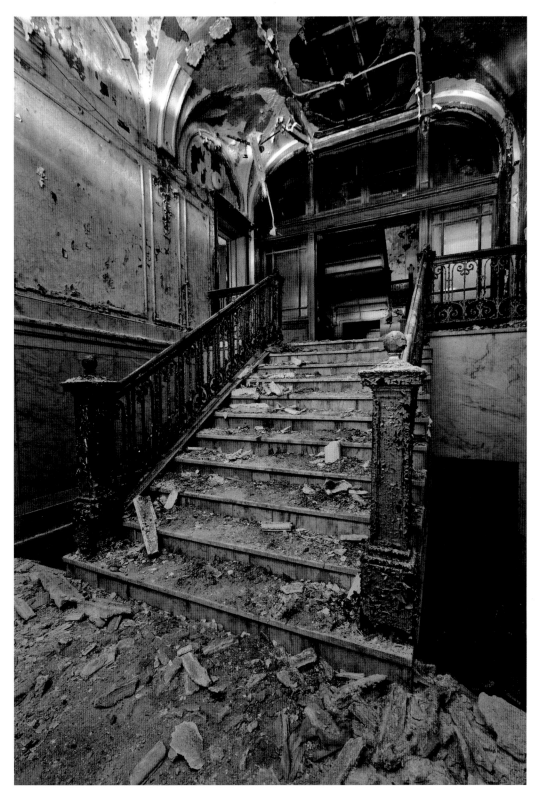

An elegant staircase of a former preparatory school turned into an addiction rehab.

The unknowingness of what beauty you may find, which has been forgotten, is the best adrenaline rush. Churches, funeral homes, and theaters sitting and decaying, scattered all over Cook County and the city of Chicago. Decrepit but beautiful, these places were once filled with so many emotions and still hold so many memories for some. This is what I hope to share with you through my photographs. A sense of what I feel and see as I explore these places that have been frozen in time, and a glimpse inside some locations that normally one would not have seen.

1

ST. BONIFACE AND OTHER CHURCHES

Saint Boniface Church was a Roman Catholic church that closed in 1990 and now sits abandoned in the city of Chicago, Illinois. It was originally established for German immigrants in 1865 who needed a place of worship. The current building that still stands was constructed between 1902 and 1904 and replaced the small wooden structure that once stood on the land. The construction of the large cathedral served the wave of displaced residents due to the Chicago fire of 1871. St. Boniface held its first mass on Christmas Day 1903.

Henry J. Schlacks is the architect of this Romanesque church, which could seat up to 900 people at a time. He is also the architect of the school and residence that once stood on the property. St. Boniface school was closed in 1983 and demolished in 2003. Henry was born in Chicago in 1868 and later became known as "the master of Catholic church architecture in Chicago," a title that was well deserved. His architectural aesthetic was formed during extensive travels overseas, where he studied church architecture. He also was an expert in what reportedly was his favorite style: Renaissance. St. Boniface has four unique asymmetrical bell towers that is now home to the pigeons that live inside. It was one of twenty-eight parishes that were closed in June 1990, and it has been sitting vacant ever since.

In 1999, the building was placed on the Most Endangered Historic Places in Illinois list in hopes to save it from being demolished. I have had the pleasure of visiting this church a handful of times throughout the years.

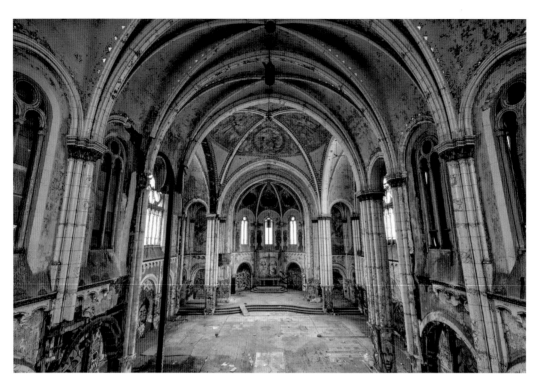

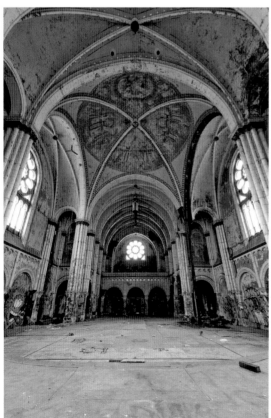

Above: View of the altar from the second-level balcony.

Left: St. Boniface Catholic Church, closed in 1990.

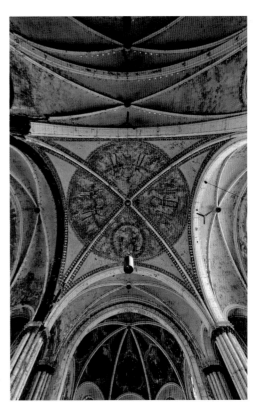

Ceiling mural that reads, "Come to me all you that labor and are burdened and I shall refresh you."

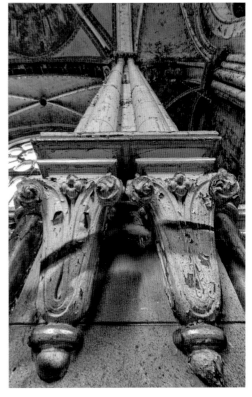

Wall details.

Walking into the decaying, vast sanctuary for the first time was an incredible experience. Rays of light peeking through the cracked boards that now cover the windows were beautiful. Periwinkle blue and Persian green paint peelings fill the walls and ceiling of this 32,000-square-foot church. Layers and layers of colorful graffiti currently still covers the majority of the lower walls in the church. Many redevelopment proposals have come and gone, but this empty church still hopes of one day being turned into something useful again. After a three-year delay, there is word that the church will be turned into seventeen condos, and a twenty-four-unit condo building planned for the empty lot next to the church.

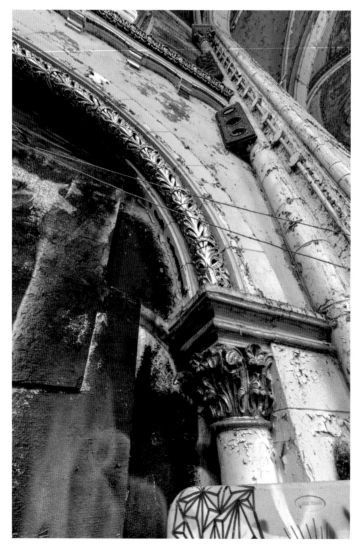

Gold-painted arches by the altar.

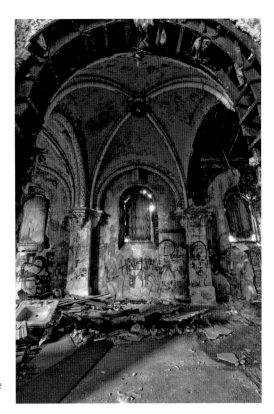

Most of the windows in this church have been boarded up. It is heavily decayed and its walls are filled with graffiti.

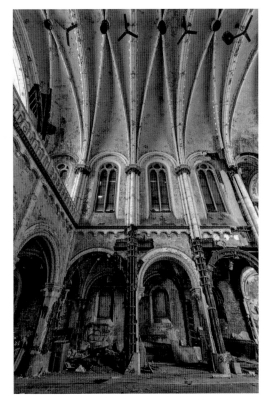

Holding so much history, this church could never be torn down.

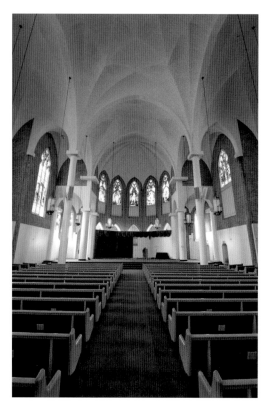

This photo was taken in July 2018. Since then, this church has been a victim to vandals and scrappers.

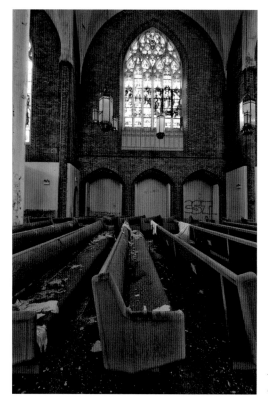

Henry J. Schlacks was the supervising architect for this church. The plans were supplied by a German architect.

Another vacant church in Chicago that also has hopes of being turned into something new is the large cathedral with a 230-foot spire that towers over the Englewood neighborhood. Henry J. Schlacks is also the architect of this Gothic Revival structure that was constructed in 1895. Even though this church was constructed in the late 1800s, the interior looked much different than the exterior does. The archdiocese closed the parish in 1989, and the building became a victim to neglect.

In November 1998, a new parish moved in, got a new roof, and updated the plumbing, heating, and electrical systems. Then, in 2007, after a bad windstorm, the large statue of St. Martin of Tours on horseback fell and was wedged farther down the roof. The sixty-seven-year-old lead and copper statue was now upside down and stuck in a nook on the roof. The cost to repair the statue would be around $30,000. Even then, the replacement statue would not be as grand as the original and would only be the horse with no rider. The church closed permanently about ten years later.

Now the church sits with holes in the roof, exposing the inside to the outside elements. The once-crisp bright white walls and ceiling are now blackened and mildewed. The emerald green carpet is now water logged and the pews are covered with falling debris from the ceiling. If it is a rainy day in Chicago, it will be raining inside of the church also. Scrappers and vandals have also heavily damaged the inside sanctuary. The future is currently still unknown for this church.

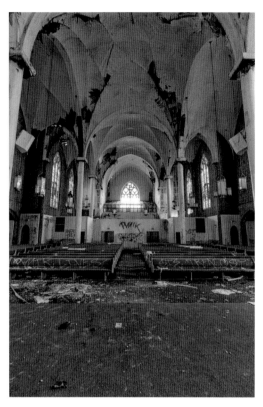

This Gothic Revival church that was built in 1894 is said to be modeled after a church in Mainz, Germany.

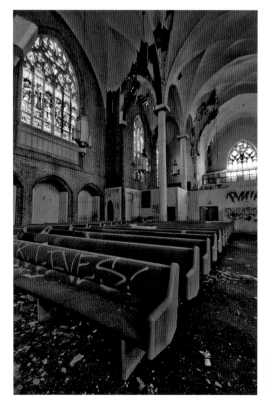

There are now numerous holes in the roof exposing the main sanctuary of the church to the outside elements.

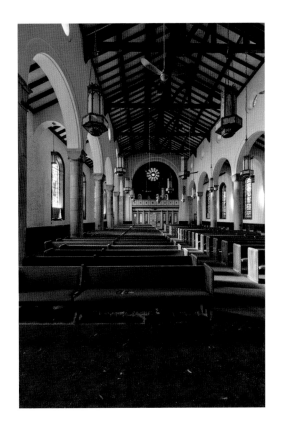

Despite this Baptist church looking to be in good shape, the basement was flooded up to the first floor.

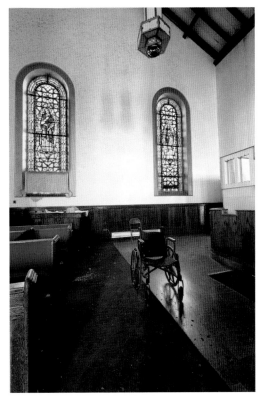

A lone wheelchair sitting in the sanctuary. You can see the start of black mold forming on the walls behind it.

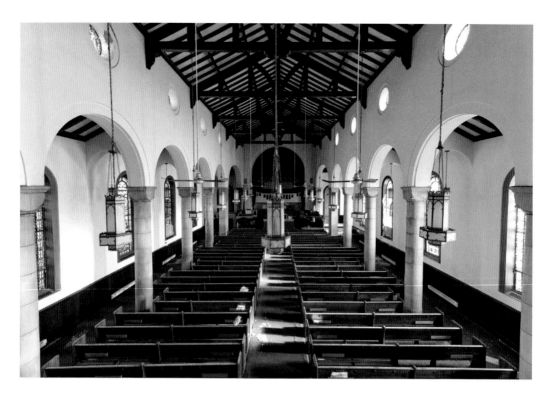

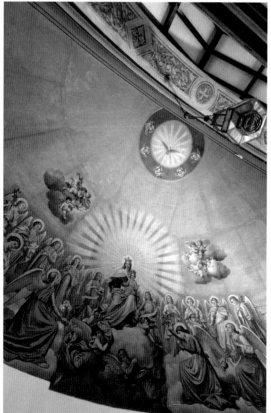

Above: View from the balcony. This church was said to be established in 1976.

Left: Pristine religious mural that is above the altar.

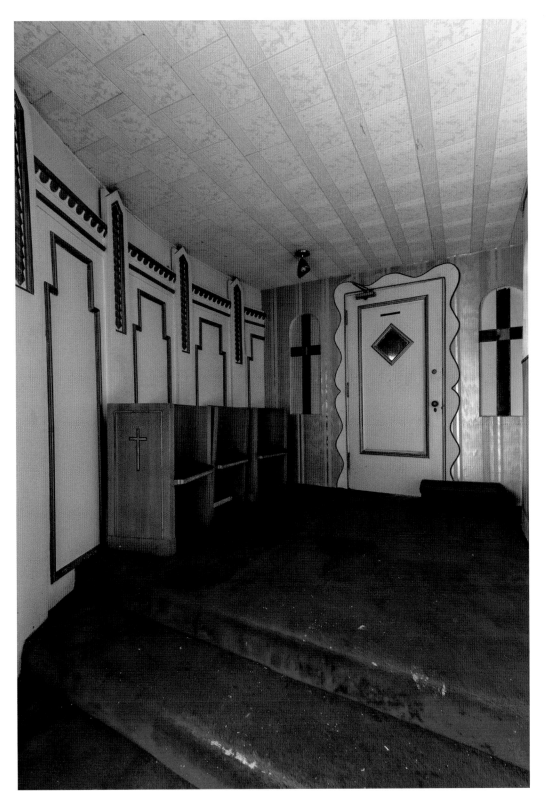

Back hallway and door leading into the pastor's office.

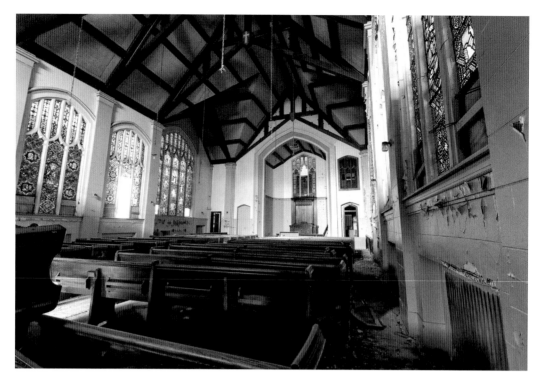

"The purple church," another well-known abandoned church in Chicago. Despite how decayed this church is, it has some of the best stained glass.

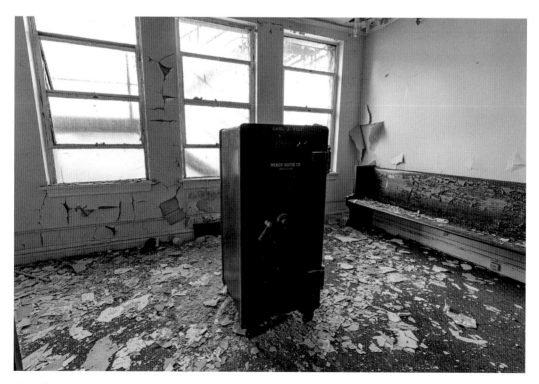

The safe that belonged to the church was left behind in a back room.

2

FUNERAL HOMES

Embalming and the burial of a deceased person has always been the most common procedure for after-life care. However, within the past six years, that has changed. The primary cause of the death of burials is cremations. A switch from burials to the much cheaper cremations, rising taxes, gentrifying neighborhoods, and the lack of parking have all contributed to the cause of Chicago losing half of its funeral homes. In 2016, for the first time, the rate of cremation in the United States surpassed conventional interments. In 1960, before the Roman Catholic Church began permitting cremations, fewer than 4 percent of America's dead were cremated. Now, funeral homes all over the city are suffering and many have had to close their doors permanently.

Not very often does one get to see behind the scenes of a funeral home. You would be surprised of the things that have been left behind. Caskets, embalming tools, body bags, and sometimes, unfortunately, even human ashes. The first funeral home I ever explored was a very memorable one. When I first entered the building, my eyes immediately saw the wooden casket sitting against the wall in front of me. To the left of it was a body lift and some old clothing on a rack. As you turn the corner, you are welcomed with the smell of decay and embalming fluid. A white ceramic table is covered with a stained sheet. The outside light shines in through the glass block window, illuminating the coral colored fluids inside of the bottles sitting on the window sill. There were still old tools sitting inside of the vintage cabinet also. As you step into the main viewing room, ceiling tiles are hanging down, the floors are covered with debris, and everything was still set up as if there was going to be a service held tomorrow.

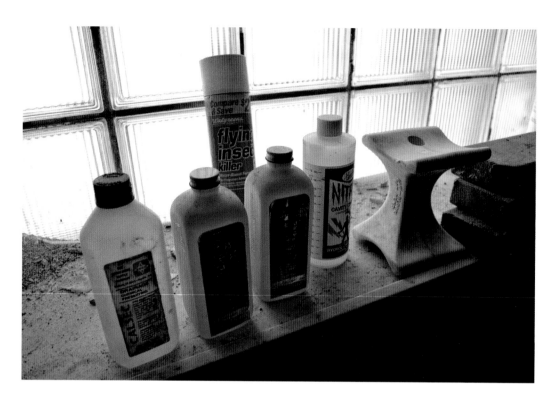

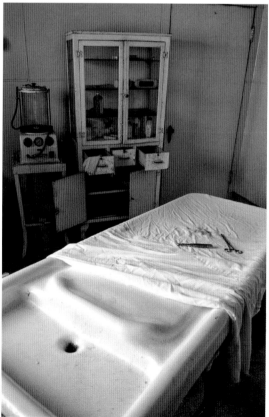

Above: A collection of different embalming fluids and a headrest.

Left: Embalming table with tools and stained sheet.

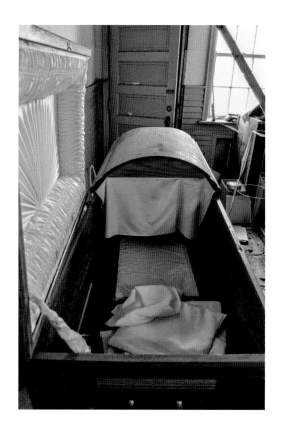

Wooden casket and its linens.

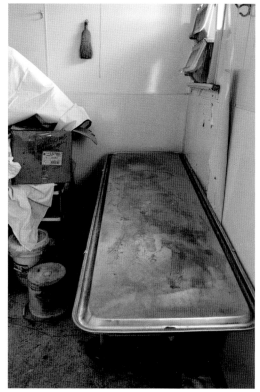

A stainless-steel gurney that is used
transport bodies. It can also be called
a cadaver carrier.

to

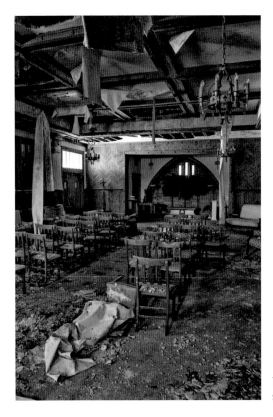

The very decayed main view room. Everything still in its place.

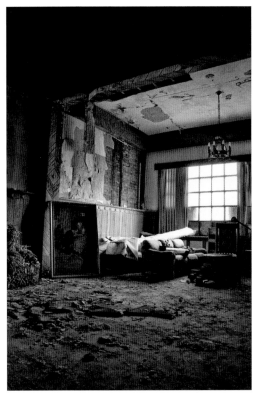

Another viewing room that was being used as storage.

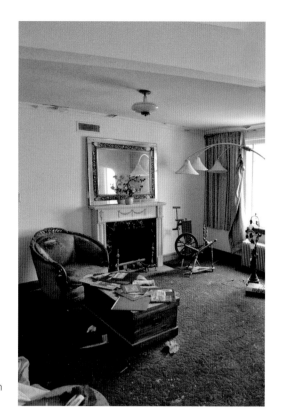

The upstairs living quarters where the owner of the funeral home lived. Every room was filled with personal items and antique furniture.

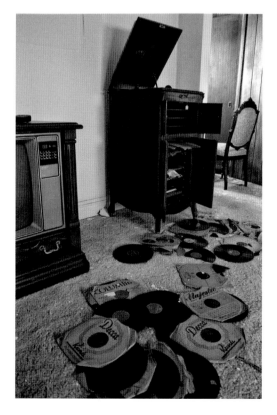

A Victrola record cabinet and vintage records.

The upstairs of this funeral parlor is where the owner slept and lived. Bedrooms were filled with personal items and there was rotting food still inside of the kitchen refrigerator. The owner's office that was on the second-level floor still had file cabinets with records that were kept. It is unclear when this funeral home exactly closed. Looking at the decay, this funeral home had to have been closed for a number of years. Today the building still sits boarded up, hoping it will get another chance to be used again.

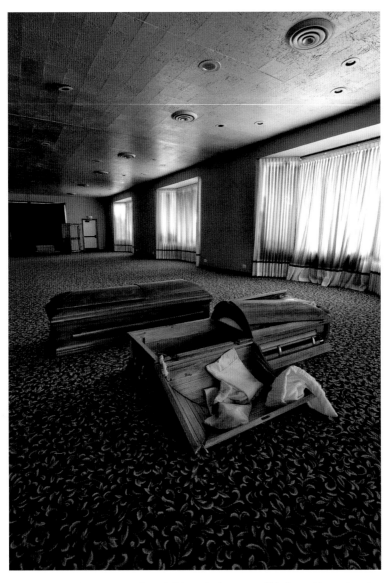

Two broken caskets that have been left in a viewing room. This funeral home is going to be demolished soon.

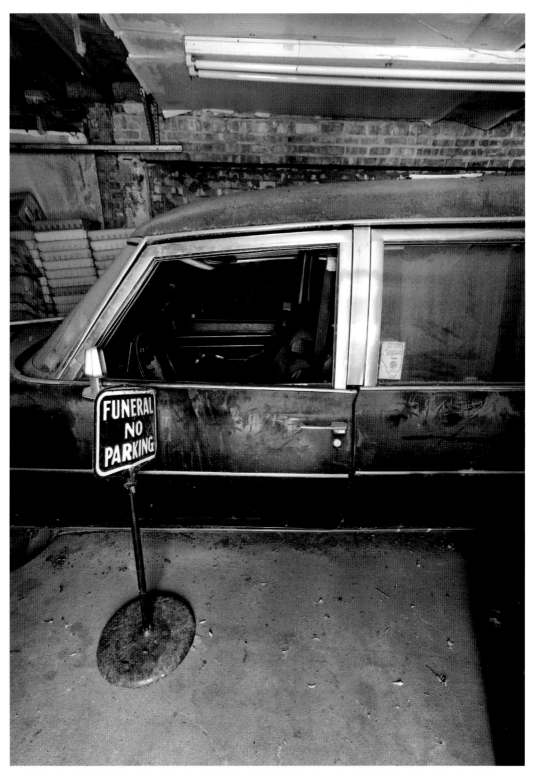

Inside the garage of this south side funeral home was a Cadillac hearse and many other items that were once used in the funeral parlor.

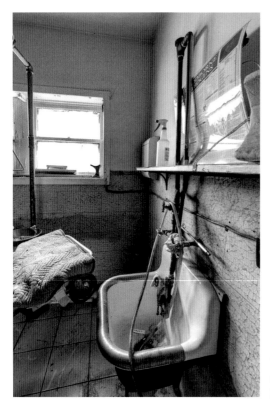

The sink in the embalming room. You can still see blood that is left in the tubing that would have been used in the embalming process.

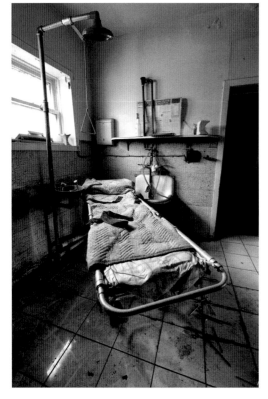

The very small embalming room. There was no embalming table in here. However, there was a gurney. The surgical tools and makeup kits used were also left.

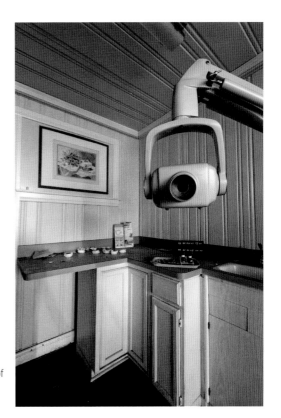

Braun Dental Clinic, demolished in the summer of 2020. This dental office had a total of three x-ray machines despite it being a very small office.

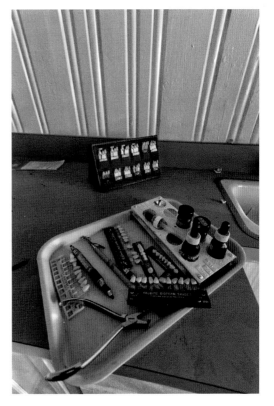

Dental supplies and models of teeth that were left.

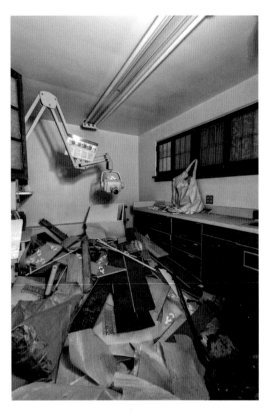

Another room with a dental x-ray machine.

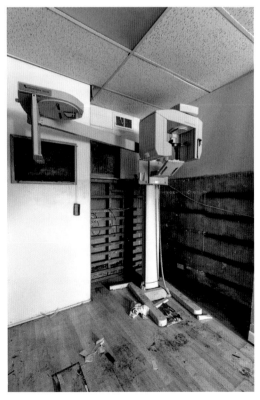

This machine is called an Orthoceph. These machines take panoramic radiographs of the mandible, maxilla, and teeth.

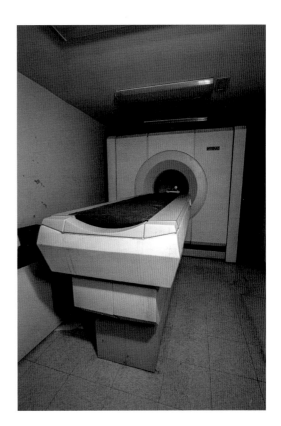

A giant CAT scan machine left in an exam
room of a very moldy medical clinic.

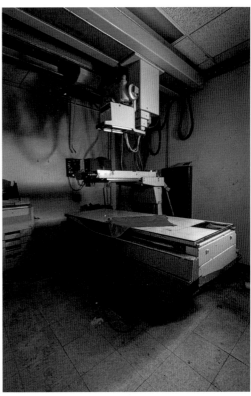

The x-ray room of a large medical clinic that
sits decaying.

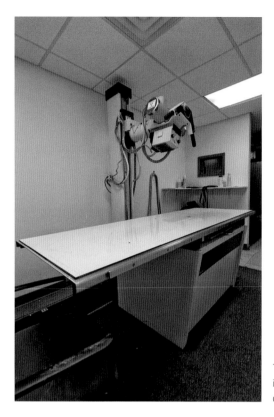

This empty medical office still had power running inside. It has since been turned into another place of business.

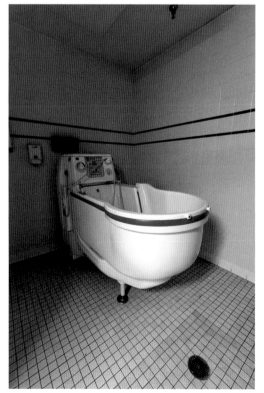

A hydrotherapy tub left in an abandoned nursing home. Hydrotherapy can be used for many types of illnesses and disorders from depression and muscle aches to acne. It can also be used for relaxation and to maintain health. This nursing home had multiple, different style tubs throughout the clinic.

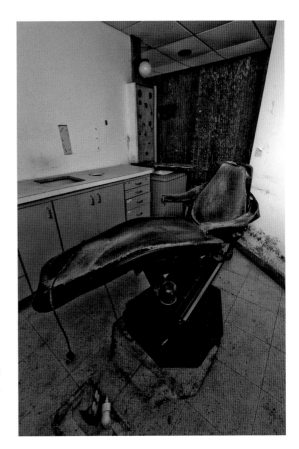

Right: This small dentist office had layers of mold covering everything.

Below: Children's exam room in a medical office.

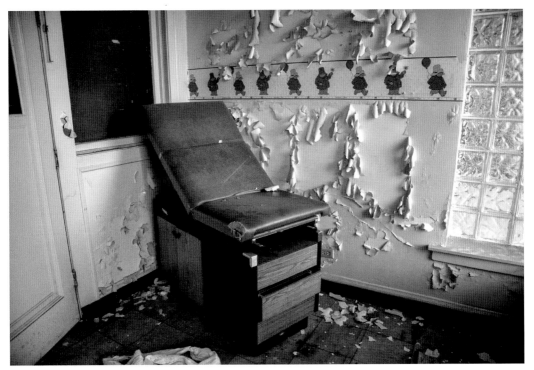

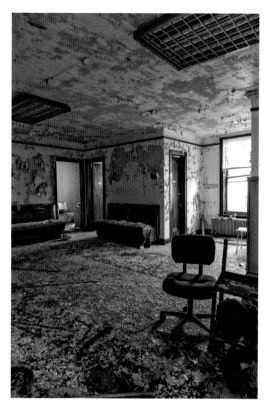

The lobby of a medical clinic on the south side of Chicago.

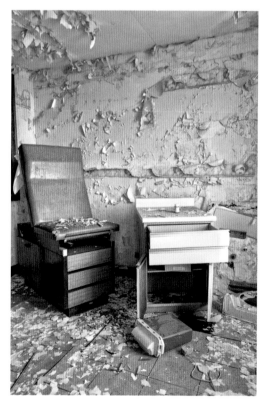

Something I find too often while exploring are sharps containers. These containers are used to safely dispose of hypodermic needles and other sharp medical instruments. This doctor's office was filled with them.

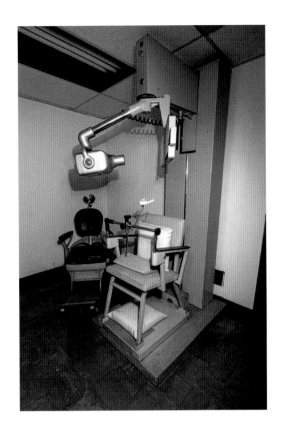

Old medical equipment left in the basement of this medical office.

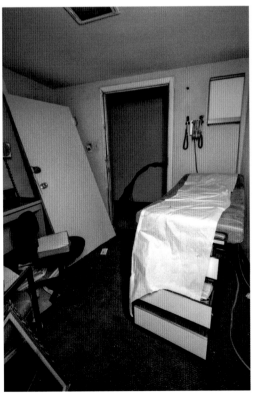

An exam room still set up for the next patient.

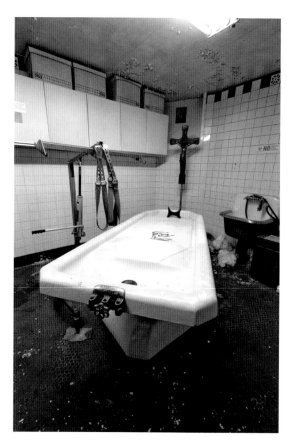

Left: An embalming table and manual hydraulic patient lift that was left in this funeral home. This funeral home seems to have closed sometime in 2016. The power was also still working inside the whole building.

Below: Some personal belongings and a large jug of Sani-Cleaner.

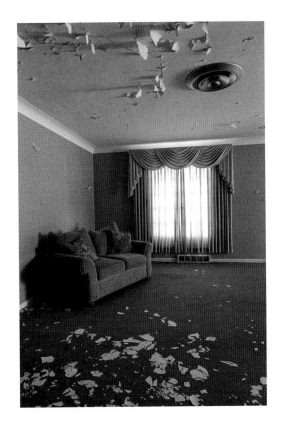

One of the visitation rooms on the main level.

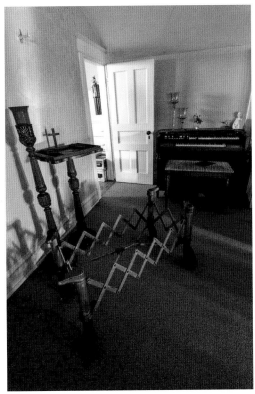

The attic of this funeral home was used as storage. It was filled with file cabinets of paperwork, casket stands, headstone markers, and religious cards.

3

MICHAEL REESE HOSPITAL AND MEDICAL CENTER

One of the largest and one of the oldest hospitals in Chicago was located in the Bronzeville neighborhood. Michael Reese Hospital and Medical Center was a major research and teaching hospital, and the construction of the first building was completed in 1880. Michael Reese, who was a real estate developer, passed away on August 3, 1878. When he died, it was his wish to have his funds go towards building a new hospital. Reese's family members had requested that the hospital be open to all people, regardless of religion, race, or nationality. Construction of the first hospital building on the property was completed in 1880. In 1899, the hospital became famous as the first U.S. medical institution to execute a motorized ambulance service.

The original Michael Reese building was demolished in 1905 and then replaced in 1907 by a much larger building. Over the years, numerous doctors and research teams founded new discoveries in medicine and the polio vaccine while practicing at the hospital. From 1954 to 1986, the hospital purchased more surrounding properties, demolishing the old structures on those properties, and then building new clinics and offices for the growing campus. The new buildings housed many things and people such as a tumor center, a psychosomatic and psychiatric institute, a city public health clinic, a nurses' residence, school building, a heart surgery center, the Siegel Institute for Communicative Disorders, and the Simon Wexler outpatient psychiatric facility.

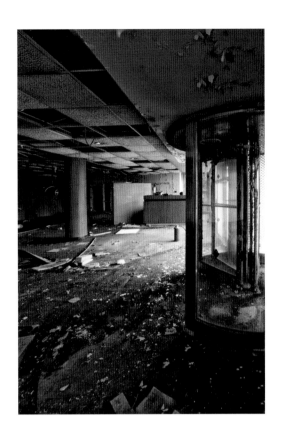

The front lobby in the last standing building
of the former Michael Reese Hospital and
Medical Center.

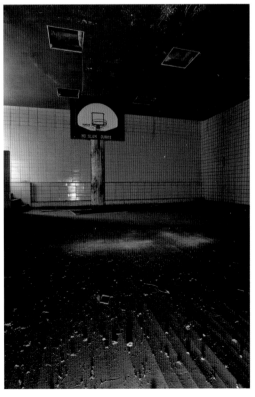

A very small gym with one basketball hoop for
the patients to enjoy.

At the hospital's prime, it had a very large staff taking care of 2,400 beds of patients. The hospital struggled financially in the late '90s, and when it closed, the hospital only had 151 beds. The 48-acre campus medical center officially closed its doors in August 2009 and demolition began in December of that same year. During the demolition, it was found that the soil was contaminated with radioactive material. By 2012, all buildings on the property, with the exception of one, were gone. The still vacant site is fenced off, leaving one standing building, which was formerly the psychiatric institute.

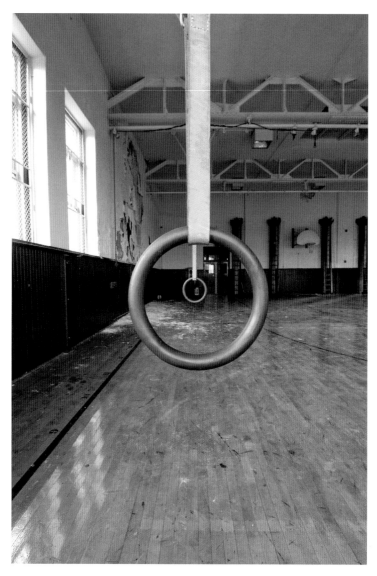

Still rings in the gym of an elementary school that was closed in 2013. This school was built in 1907.

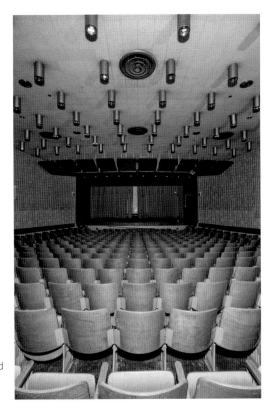

This elementary school opened in 1962 and closed in 2014. While the rest of the school is in terrible shape, the auditorium is still is good condition.

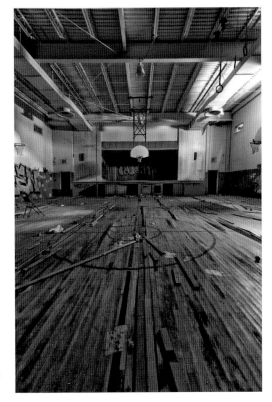

Another elementary school that was closed in 2014. This school served around 300 students in grades prekindergarten to eighth grade. This is the school's gymnasium.

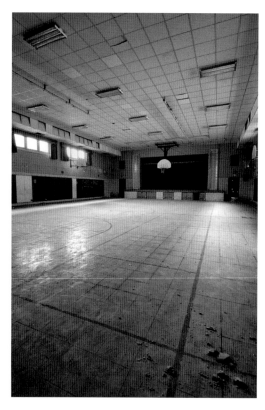

Elementary school gym. This school was one out of fifty schools that closed their doors in 2013.

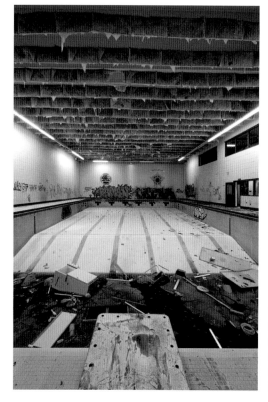

The very large pool at the former Near North Career Metropolitan High School. After the school closed in 2001, the building was used as an auxiliary training site for police officers and firefighters. The building was demolished in September 2020.

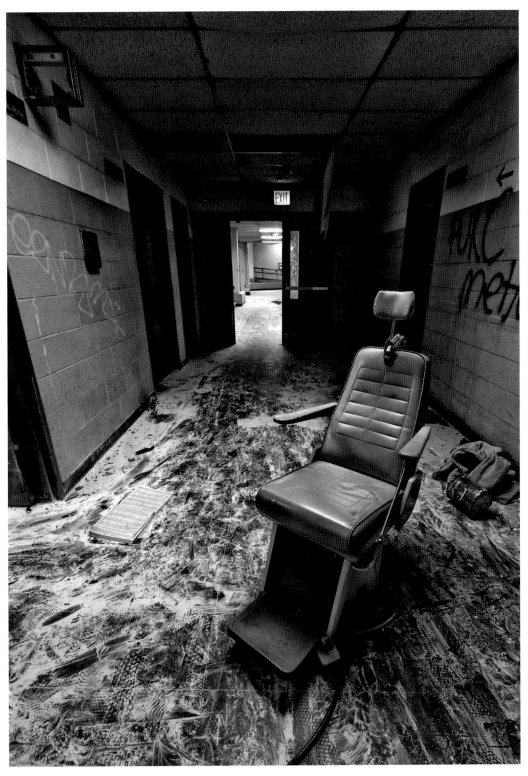

A medical chair that was once used in this school. Fire extinguishers were sprayed by kids which is the white powder that covers the floors.

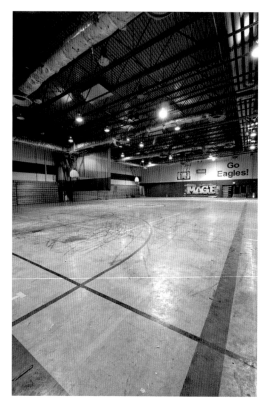

The gym at the former Near North Career Metropolitan High School. The power was still on in this school.

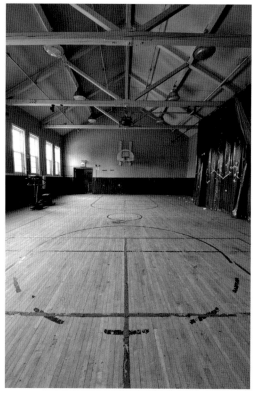

A very old gymnasium of a former school in Chicago's Woodlawn neighborhood.

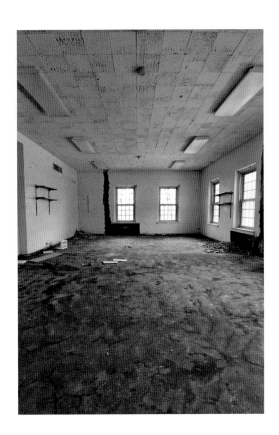

The yellow classroom.

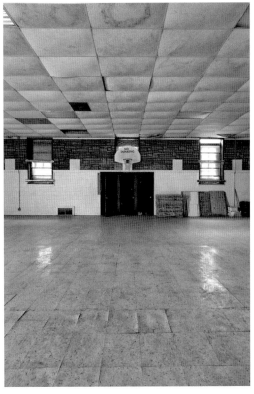

This gym was formally the church of
the school it is attached to.

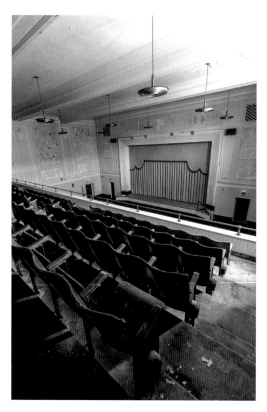

The auditorium of a former elementary school in Chicago's Englewood neighborhood. This elementary school has now moved into a new building that was also a previous former vacant school.

Details on the walls in the auditorium. There have been proposals to redevelop the school into affordable housing units for seniors.

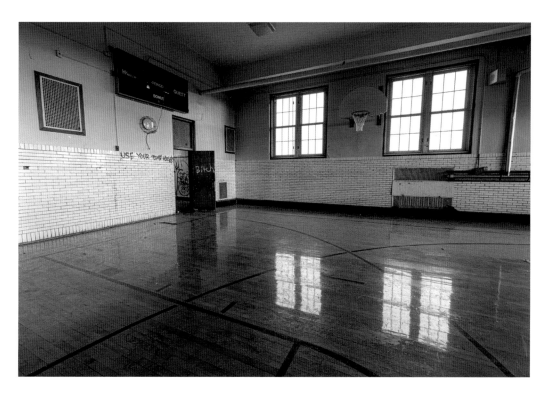

Above: The gym in the former elementary school. Inspirational graffiti written below the clock on the wall reads, "use your time wisely."

Right: Children from grades prekindergarten to eighth grade attended this school and there were around twenty teachers that had taught here at one point.

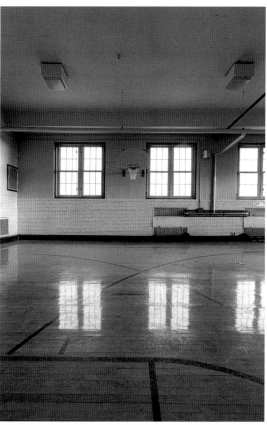

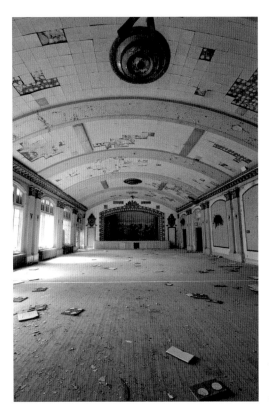

This building was formerly used as a banquet hall and entertainment venue. It has fallen into disrepair and is for sale.

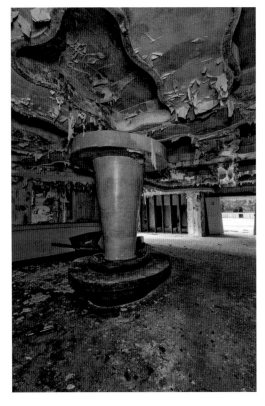

The waiting lobby ceiling had an interesting design pattern.

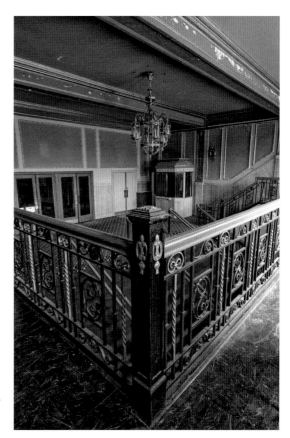

Right: The detailed and colorful theater lobby.

Below: Ticket booth.

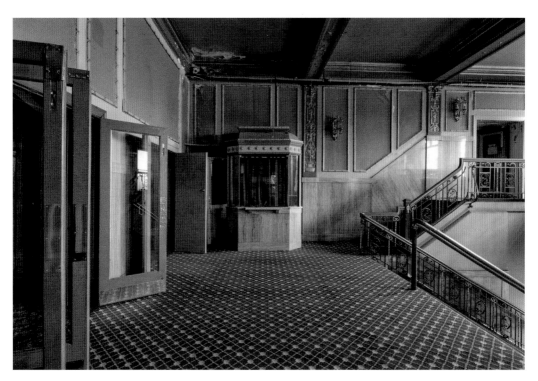

4

THEATERS

Home to over 200 theaters, Chicago is a must-see city for theater lovers. With that being said, many are sitting vacant. This French-Renaissance style theater opened in 1927 originally as a ballroom, and it is one of my top five favorite theaters that I have photographed. Pink and gold walls and a bright red floor is what welcomes you as you first enter the theater lobby. Housed within a larger building, the facade is a downplayed Neo-Classical style.

Inside the theater auditorium there is a large, hand-painted mural above the stage. The room is filled with red seats and its matching bright red curtain. In November 1937, it was turned into a movie house until its closing in 1993. In 1994, it was renovated and briefly reopened, but then closed within the year due to lease complications. In the early 2000s, the theater was reopened again, being used for live dinner shows and a banquet hall.

In 2012, the town officially deemed the building a historical site. In January 2018, a fire started in a rooftop heating unit. There was no severe damage to the inside of the building, only smoke damage. The theater is now closed and surrounded with vacant storefronts. Dust covers the glass doors and cobwebs form on the seats. There is still hope that it will be filled with the laughter and the sound of applause of the audience once again.

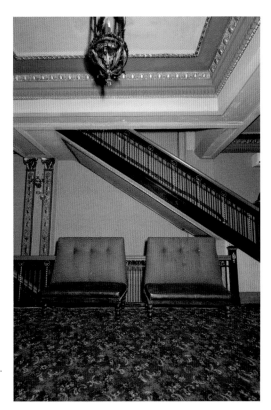

The waiting area outside of the theater auditorium. This theater also had a mirrored wall bar for people to enjoy.

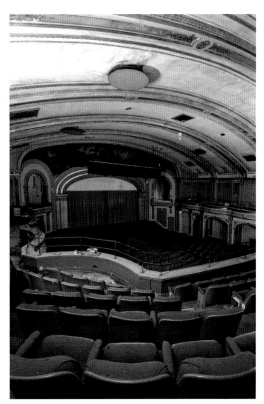

John A. Mallin, who was a mural and fresco painter in the Chicago area in the twentieth century, painted the mural that is above the stage.

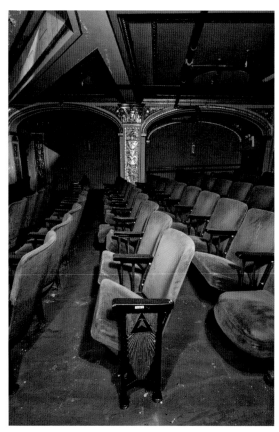

Left: Art Deco designs on the seats.

Below: This theater provided a home for a range of theatrical acts throughout its lifetime.

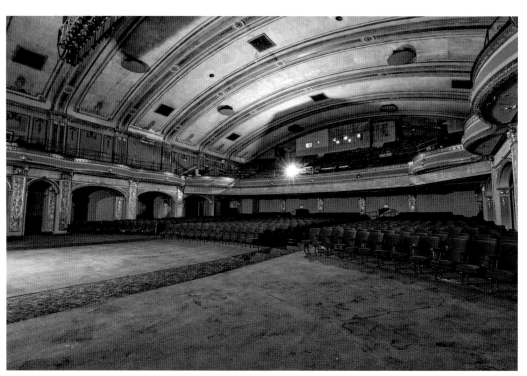

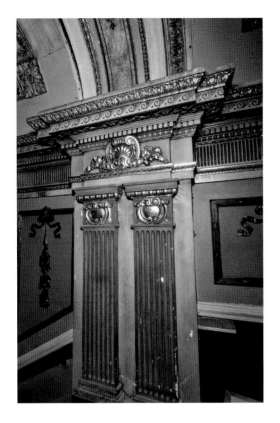

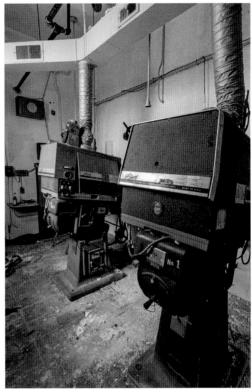

Clockwise from top left:

Theater auditorium wall details.

Projection booth.

Storage room.

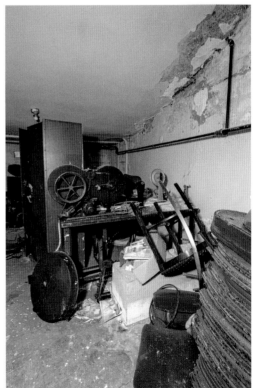

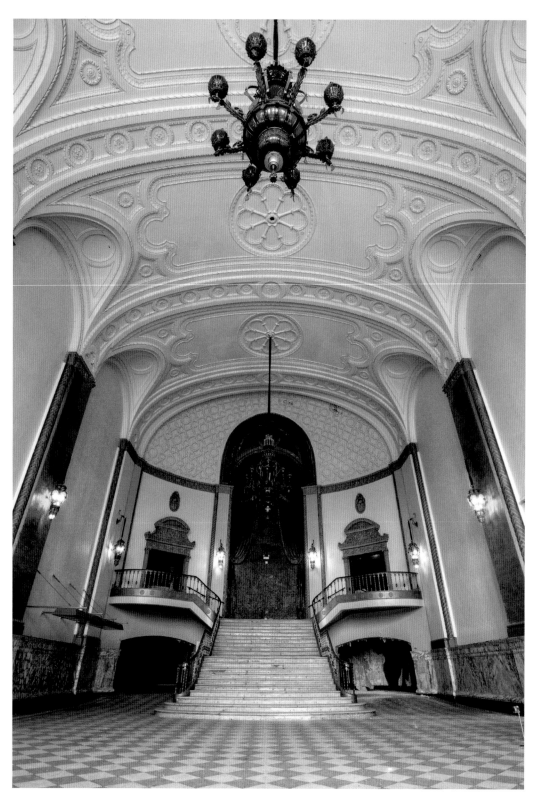

The lobby of a very historic theater in Chicago which is on the National Register of Historic Places list.

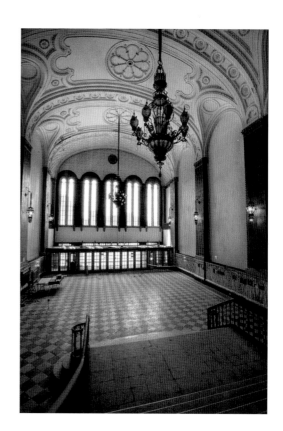

Designed in 1925, the interior design work is a combination of Classic Revival and Italian Renaissance styles.

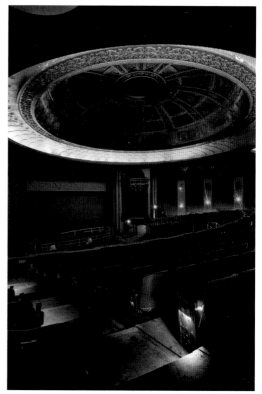

In its heyday, this theater could house up to 2,900 movie watchers.

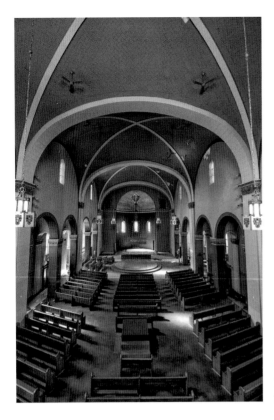

This Roman Catholic church was closed due to the archdiocese merging parishes.

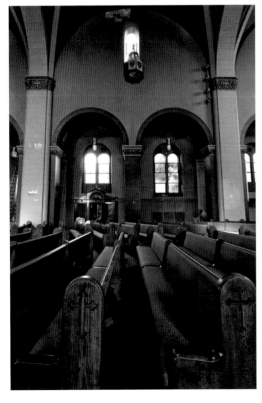

Pew details.

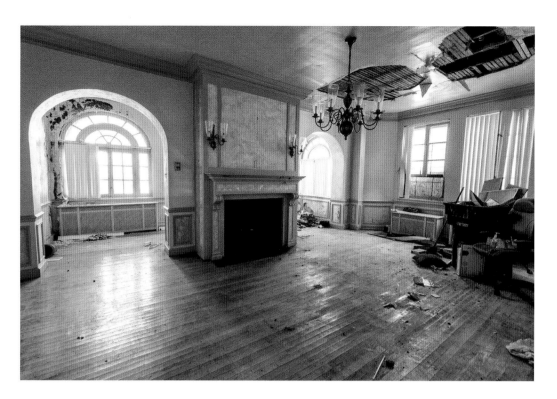

Above: Cozy back room of the church.

Right: St. James Methodist Church in Chicago's Kenwood closed its doors in 2010; it is now in the process of being redeveloped into apartments.

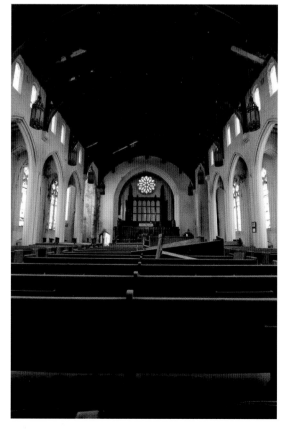

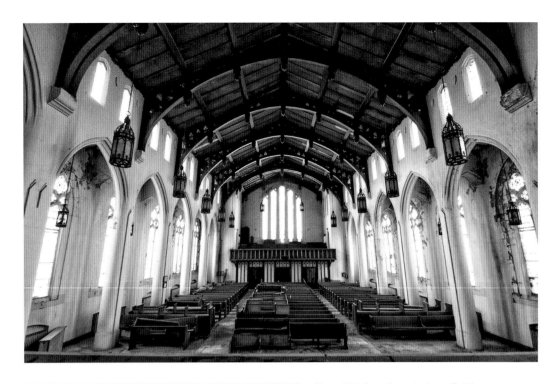

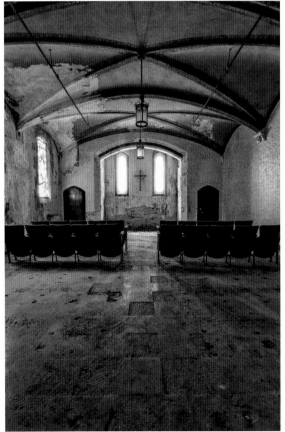

Above: This limestone-clad neo-Gothic structure was designed by a Chicago architecture firm. It was completed in 1925 after a fire destroyed an earlier church that sat on the corner.

Left: The chapel.

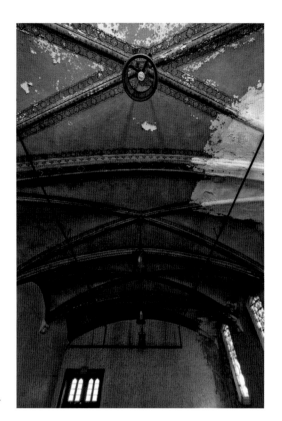

Hand-painted details on the ceiling of the chapel.

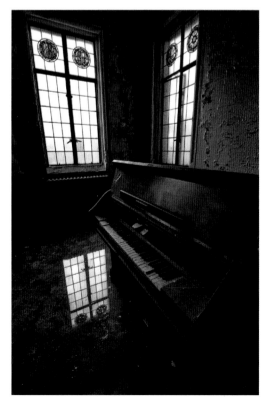

This half-flooded chapel, located next to a former church in Pilsen, has hopes of being saved by the community.

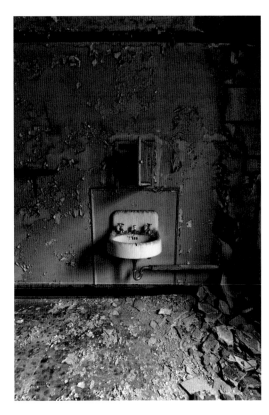

Crusty sink.

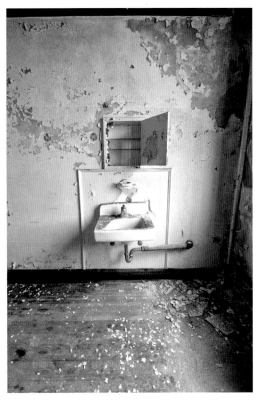

This building had some great paint peelings.

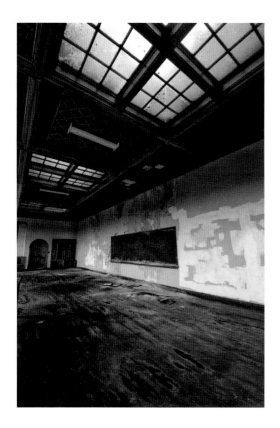

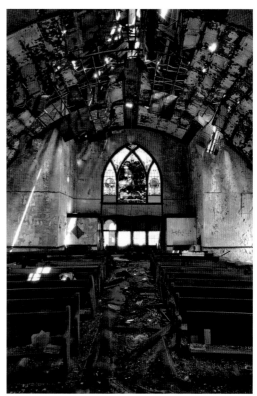

Clockwise from top left:

Classroom with a skylight.

Heavily decayed Baptist church. The floors inside here were terrible to walk on. There were even mushrooms growing out of the carpet on the floors.

Lobby of a former church.

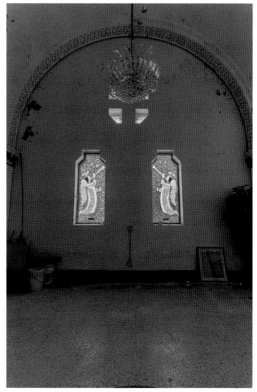

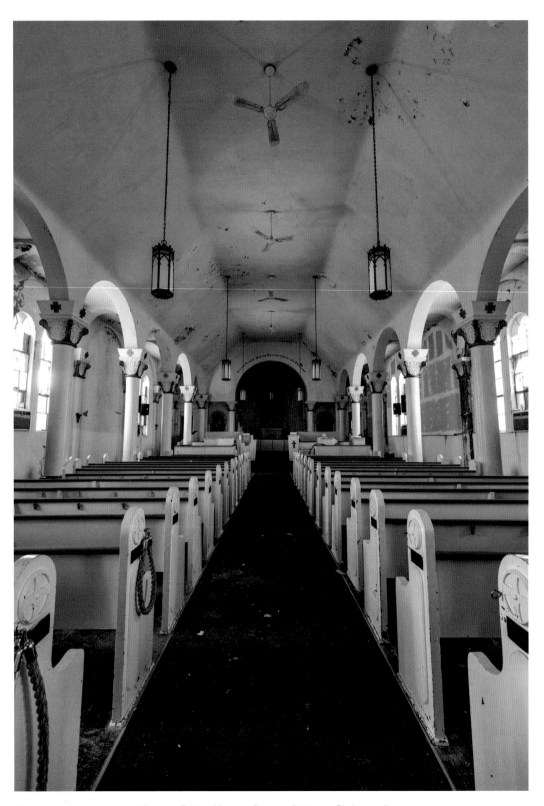

Writing above the altar says, "God our Father. Man our Brother. Christ our Redeemer."

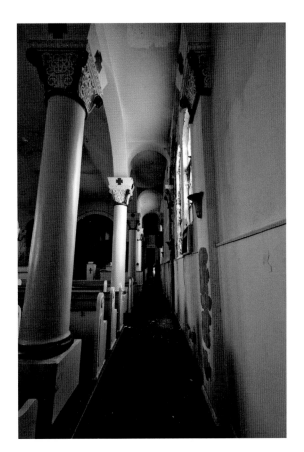

Right: This church was fortunate enough to get a second chance and be used once again. It is currently being remodeled.

Below: I like to refer to this church as the "pigeon church." There were pigeons flying above us while photographing it. For how badly this church is decayed, most of the stained glass is still intact.

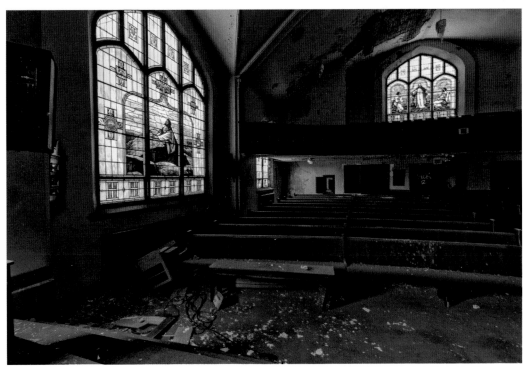

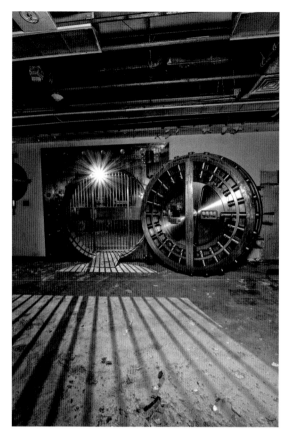

Left: The very large vault in the old U.S. bank in Chicago's Galewood neighborhood. Demolished in 2020.

Below: The safety deposit room was located in the basement.

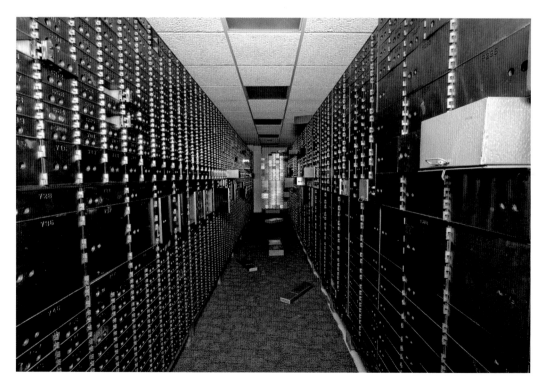

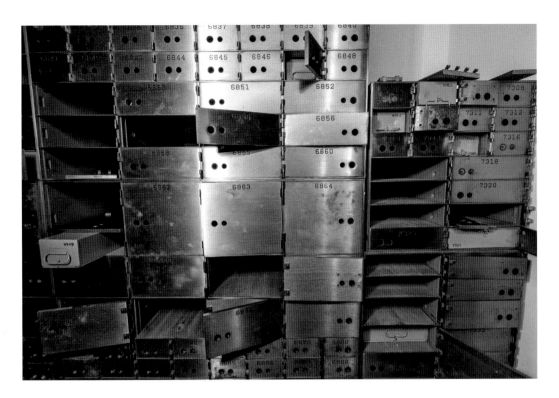

Above: Safety deposit boxes.

Right: Drunk tank.

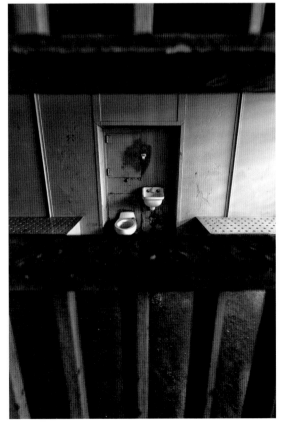

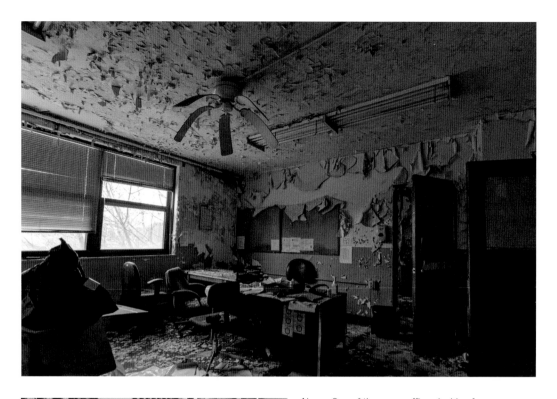

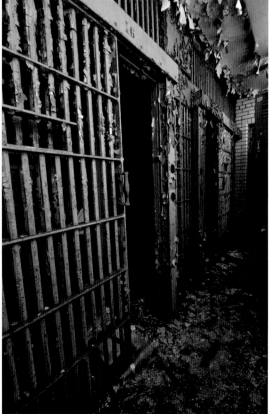

Above: One of the many offices inside of this inactive police station. So much was still inside of here. Mugshots of criminals on corkboards, file cabinets of paperwork, and evidence were all left behind.

Left: One of the cell blocks. This police station closed in 2012 due to a consolidation plan.

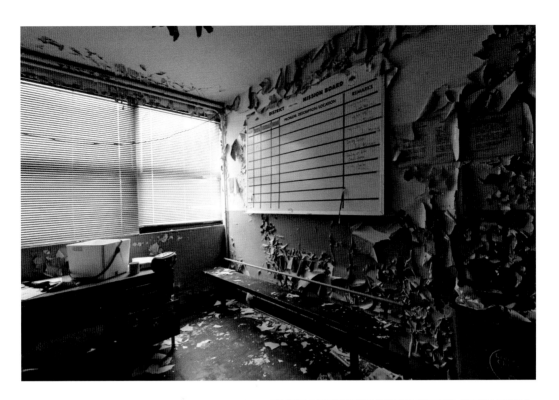

Above: Meeting room with a detailed mission board.

Right: A restraint chair in this vacant Chicago Police Station.

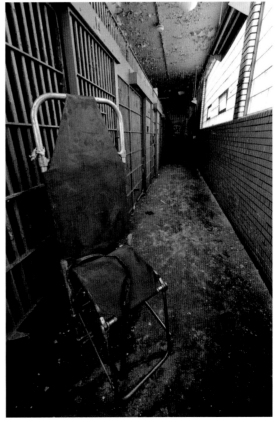

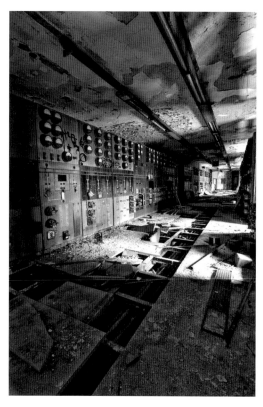

If you made one wrong step on this substation floor, you would fall to your death.

This Classical-Revival style substation was built by architect Hermann Von Holst.

5

THE WRIGLEY GUM FACTORY

The very large and very old factory that sits on the corner of Ashland Avenue and West 35th street in Chicago is the Wrigley Gum Factory. Built in 1911, and producing big-name gum flavors such as Juicy Fruit, this massive building was 175,000 square feet and took up most of the block. In business for ninety-five years, the chewing gum plant permanently closed in 2006 and halted making those name brand gum flavors that we loved. The plant closed due to an agreement that was not kept and many jobs were lost because of it.

Numerous developers over the years have showed interest in turning the location into a number of things, but nothing was ever finalized. Residents and preservationists in the city hoped that developers would keep the building, but unfortunately, in December 2013, demolition crews began tearing down parts of the building. It was said that it would be replaced with restaurants, retail stores, a bank, and a big box store. Yet again that plan fell through, and in 2020, demolition began again; in its place will be new industrial construction providing a large number of fresh jobs.

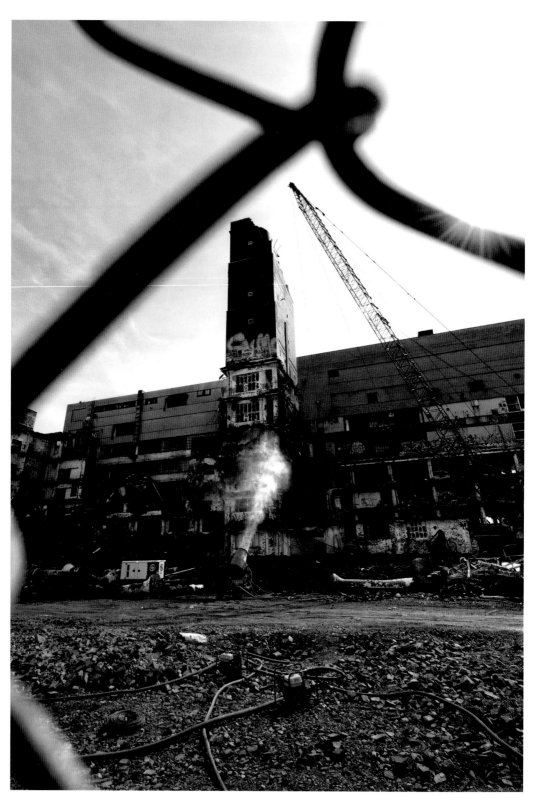

The Wrigley Gum factory during demolition.

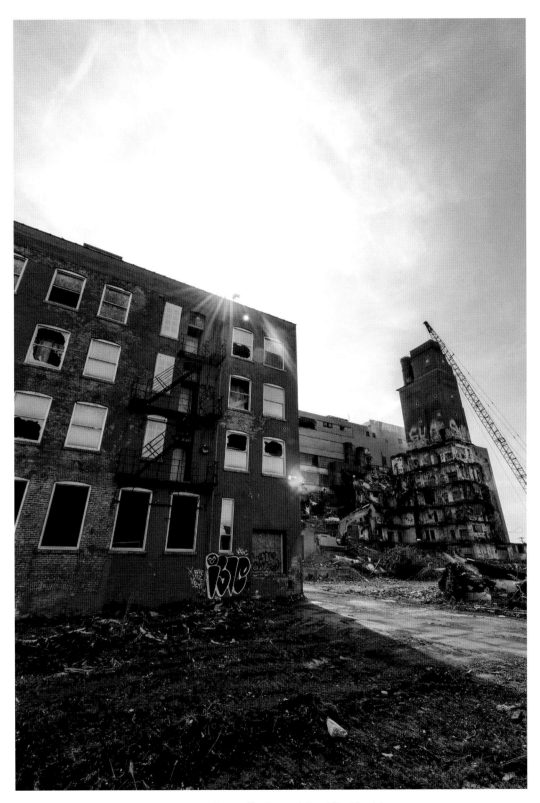

This factory produced signature gum flavors, like Spearmint and Doublemint.

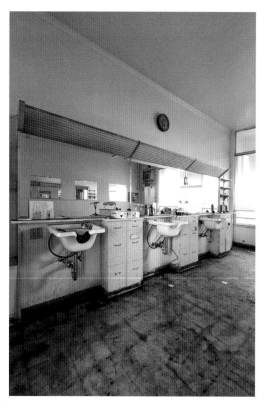

All that was left of a barbershop.

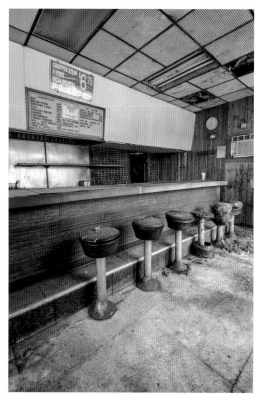

This greasy diner closed in early 2013 due to business declining. It was a twenty-four-hour diner that served breakfast all day and night long.

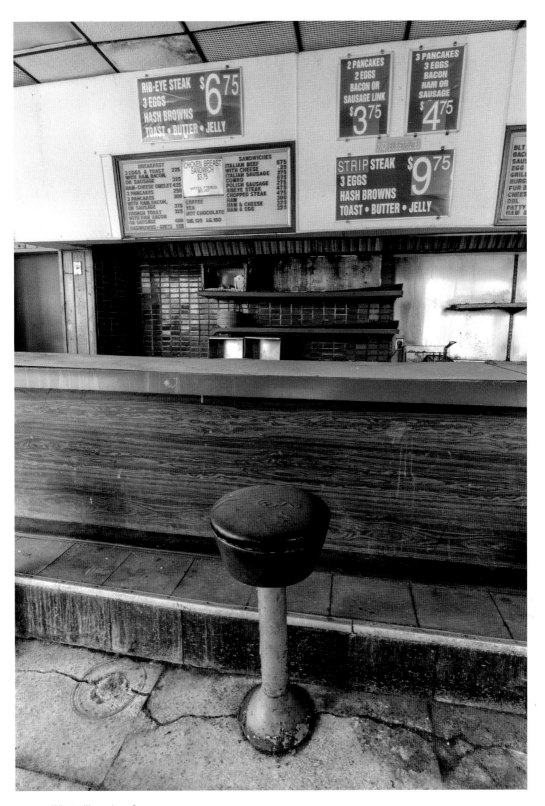

What will you have?

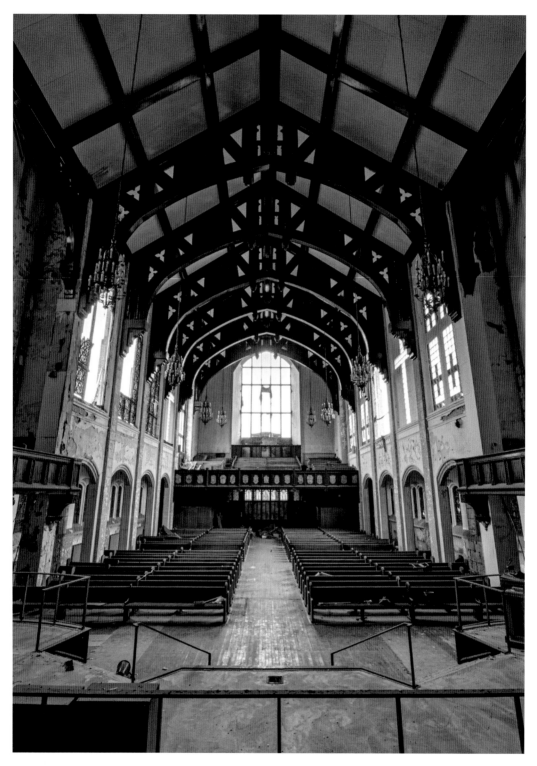

This community church was damaged by a windstorm and permanently closed sometime in 2014. Then in March of 2015, the city of Chicago demanded the church to be secured and declared it "hazardous" and an "ongoing nuisance."

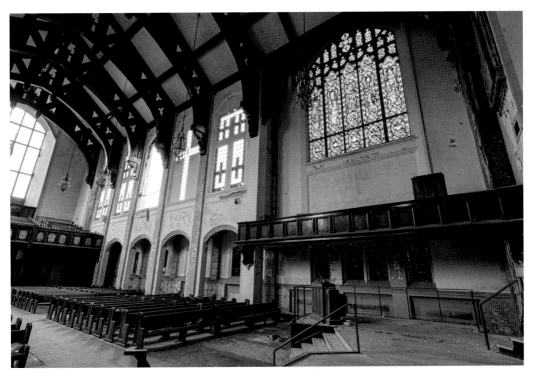

The owner 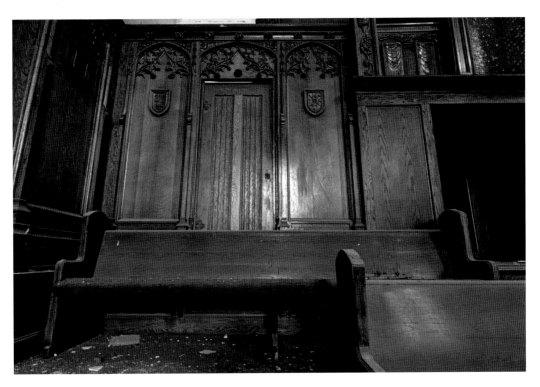 is currently in the process of trying to restore it hoping it will help rebuild the neighborhood of Englewood.

Intricate designs carved into the wood behind the altar.

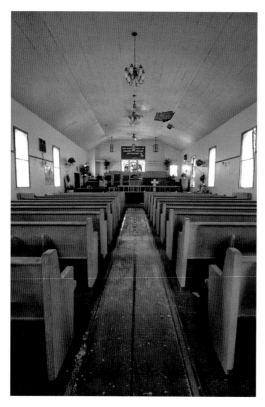

This very small church had everything left inside as if service was going to be held tomorrow. However, this church was damaged by water and had feral cats living inside of it.

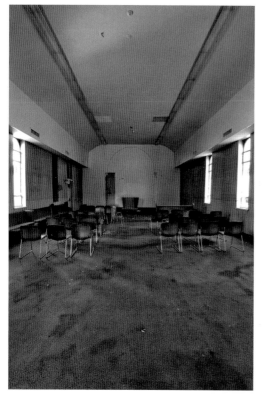

A very small church that is also connected to a small home. Both have been taken over by squatters.

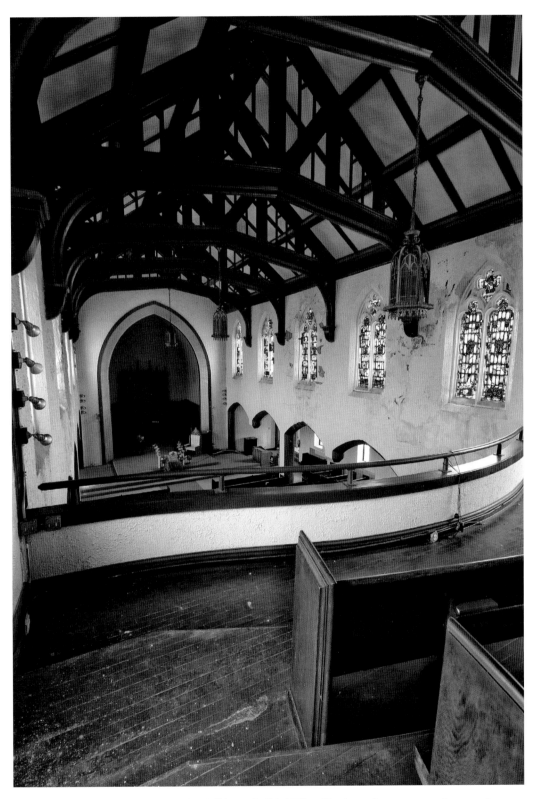

This vacant church on Chicago's South Side was built in 1925 and has housed many congregations over the years.

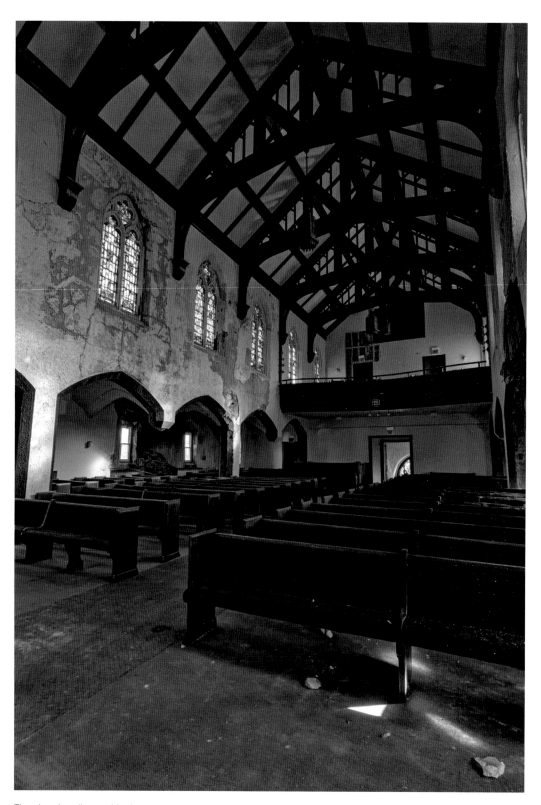

The church walls are chipping away more and more each time I visit.

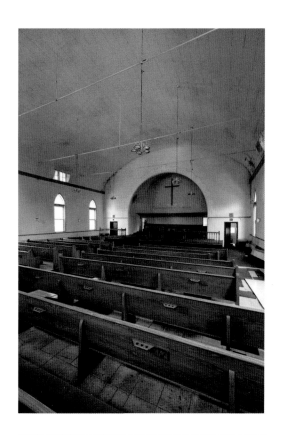

"For the joy of the Lord is your strength."

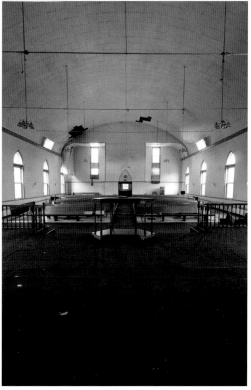

In a few years, the ceiling here will look like a game a Tetris.

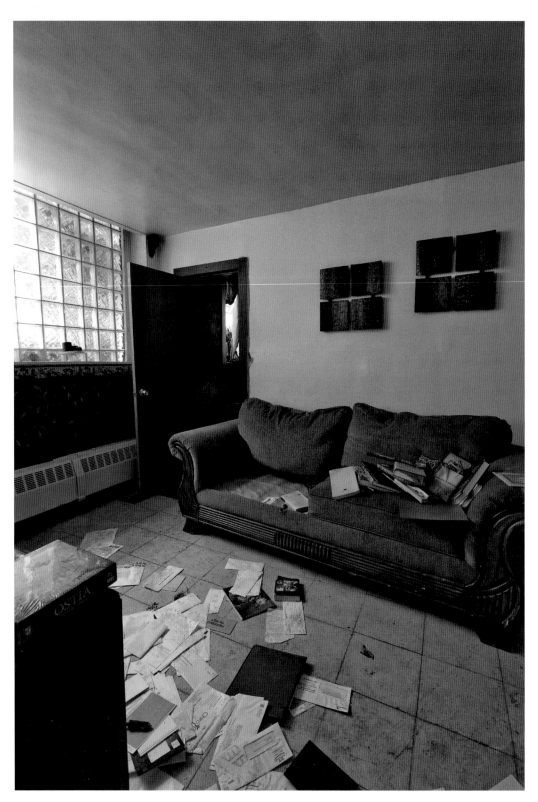

The pastor's office.

6

TENTH CHURCH OF CHRIST SCIENTIST/ST. STEPHEN'S CHURCH

T he grand church that sits abandoned in Chicago's Hyde Park neighborhood is well-known among the urban exploring community. With its massive domed interior, it was constructed as the Tenth Church of Christ Scientist in 1917. The Christian Scientists held services there until sometime in the late 1960s, until it was then bought by another smaller congregation. It was then renamed as St. Stephen's Church. Many years and many services later, the church closed their doors permanently sometime in the 1990s and was sold to a private investor. His hopes and plans were to demolish the church while saving the front facade and to then replace the dome structure with condominiums. Since at least 1997, developers have been trying to redevelop the limestone church. Sometime in 1997, another investor stepped in and began a ten-year battle with the neighborhood and finally the bank. Unfortunately, no one could agree on the specifics of his planned condo development. The bank eventually foreclosed on the property in 2007 and it awaits its unknown future.

It is tremendously decayed and the floors could collapse at any moment. The main sanctuary is elevated one story above the ground and it is approached by the grand staircases located at the northeast and southeast corners. As you make your way up the debris-covered stairs, the natural light starts to peer in through the shattered windows above. Your eyes immediately gravitate up to the massive dome structure that is above you. In the middle of the dome, there is a circle design with stained glass. Even though this design is not colorful and bright like traditional stained glass, there is intricate filigree design. Dirtied white paint peels along the walls and ceiling fall as the pigeons soar around above. The flooring is warped and you have to constantly watch where you are placing each foot as there are many holes scattered throughout the floor. This massive church will hopefully be restored and once again appreciated by the neighborhood.

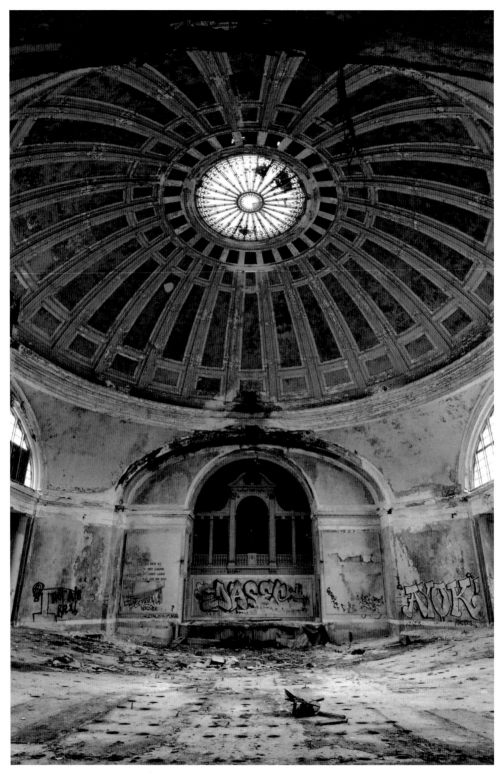

The well-known, St. Stephen's Church in Chicago. Constructed in 1917. This is my favorite abandoned church I have ever photographed.

Right: Cluttered hallway filled with items that were left in the classrooms.

Below: This school library was still filled with hundreds of books.

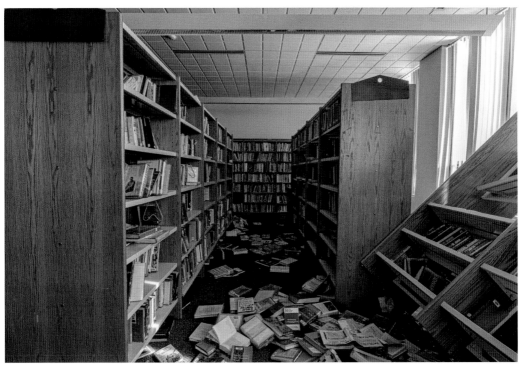

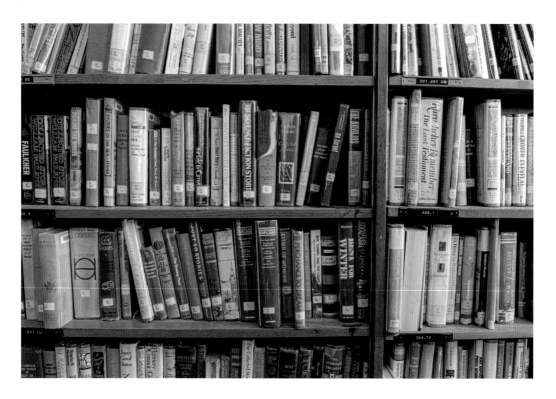

Above: What should I read next?

Left: Metal ice bathtub used for the athletes that attended this school.

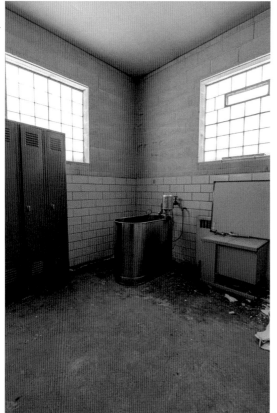

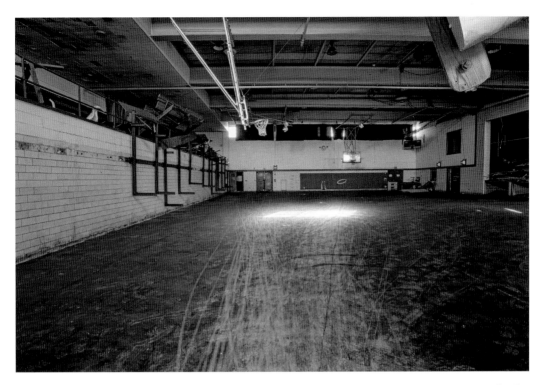

By the time I visited this school, they had already begun construction and ripped up the old wooden flooring that was in the gym.

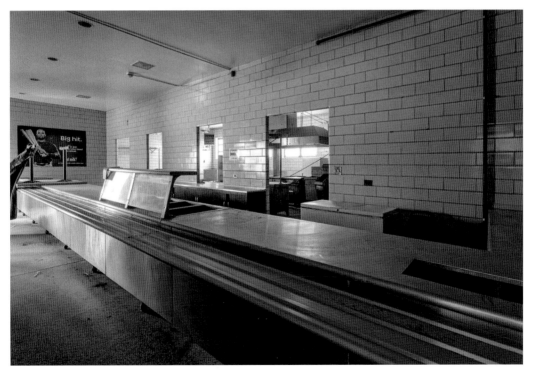

The lunch line.

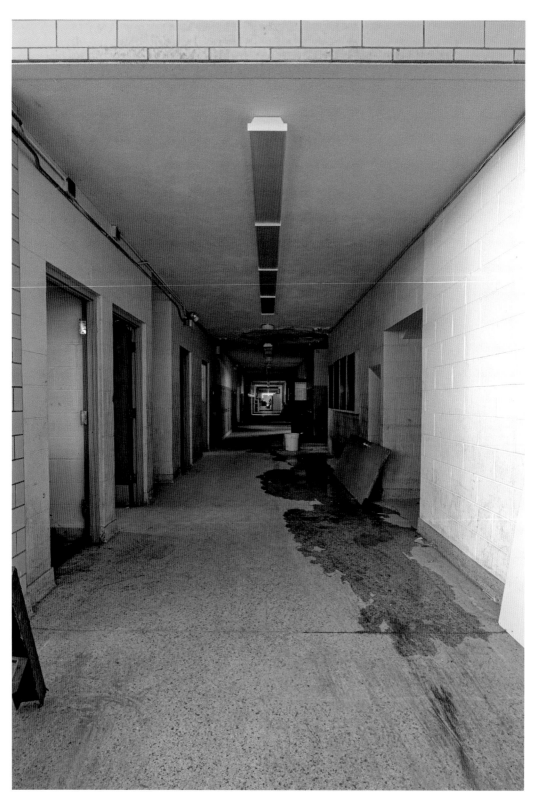

Rapper Common graduated from this high school.

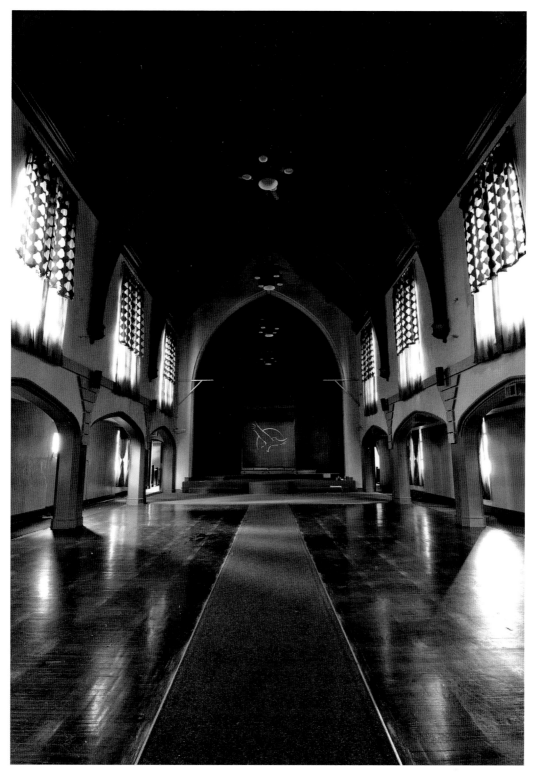

Iglesia de Cristo was demolished to make way for housing developments in 2020. This church building was almost 100 years old when it was torn down.

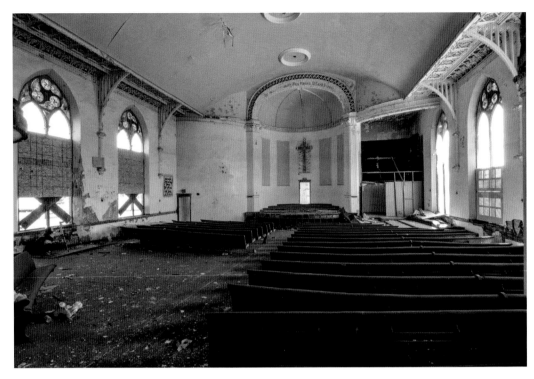

St. Stephenson Missionary Baptist Church, now demolished.

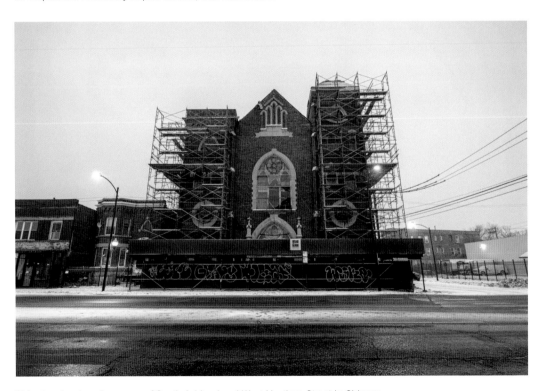

This church sat on the corner of South Ashland and West Hastings Street in Chicago.

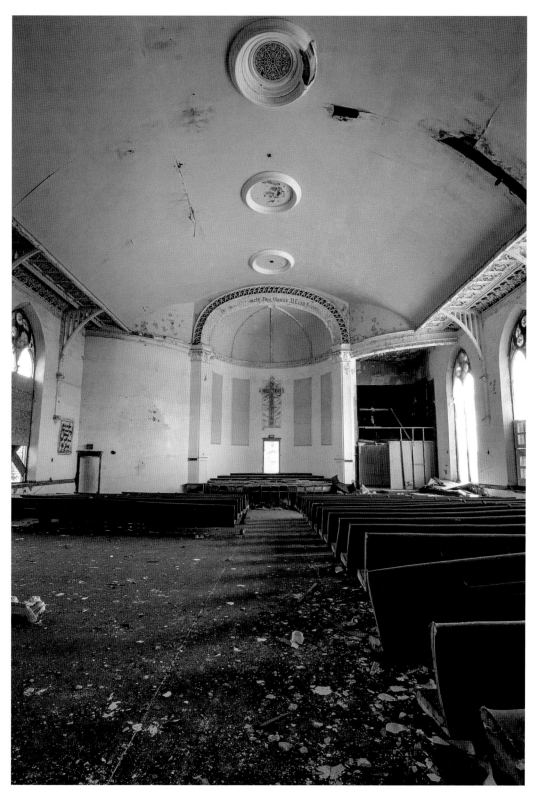

A number of congregations over the years have been housed in this church.

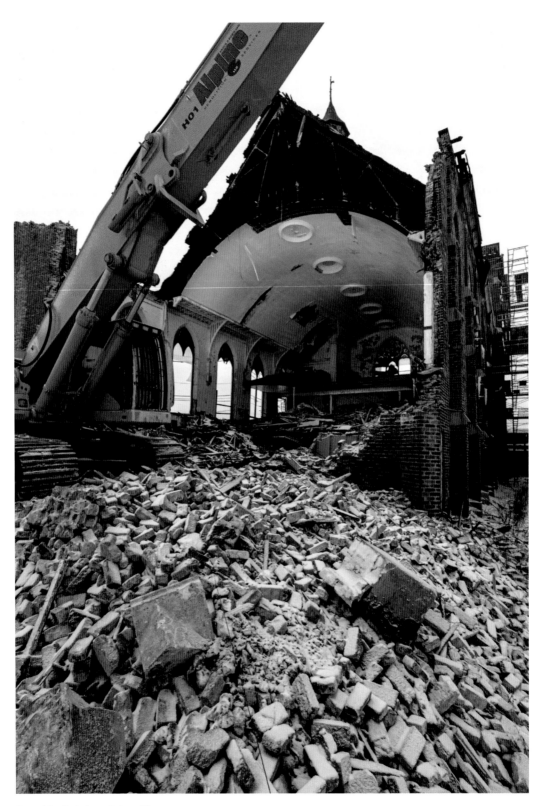

One of the first days of demolition.

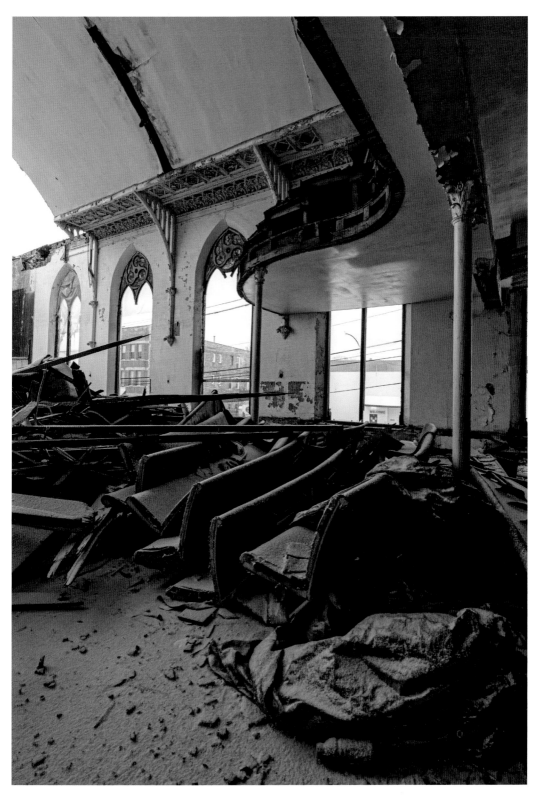

Built in 1905 by Theodore Duesing.

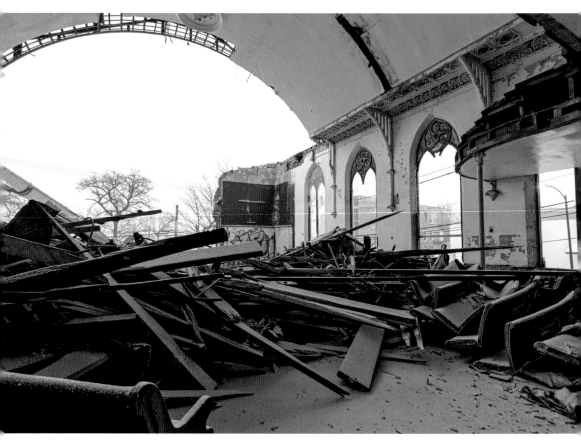

With the church being leveled, it has been said that a four- or five-story building will take its place. The said plan is that the building would house community service businesses and a non-profit collaboration space.

BIBLIOGRAPHY

afterthefinalcurtain.net
cinematreasures.org
en.wikipedia.org
johnamallin.com
preservationchicago.org
www.chicagobusiness.com
www.dnainfo.com
www.landmarks.org
www.saintbonifaceinfo.com
www.wbez.org

ABOUT THE AUTHOR

ALISON DOSHEN is a self-taught photographer from the suburbs of Chicago and has been taking pictures since childhood. Landscapes and nature were her first inspirations, and over the years, she has found a new passion photographing lost and forgotten places. Alison enjoys capturing the architectural features that have been lost in time and her goal is to help save and preserve these places through her photographs. Her photos have been published in the *Daily Herald* and *Vacate Magazine*: Issue III and Issue IV. To see more of her work, visit her website www.alisondoshen.com or her Instagram page @alisonnn07.